WOMEN IN

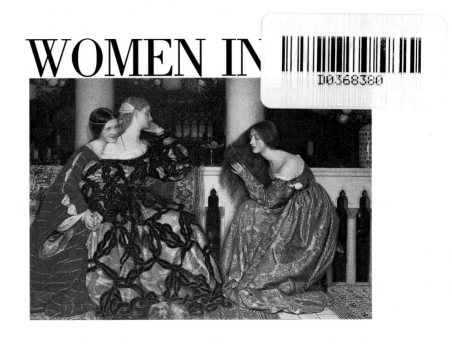

FAWCETT COLUMBINE · NEW YORK

A Fawcett Columbine Book
Published by Ballantine Books

First published in Great Britain in 1991 by
PAVILION BOOKS LIMITED
196 Shaftesbury Avenue, London WC2H 8JL

Text Copyright © 1991 by Pavilion Books
Illustrations – Copyright and sources as indicated
on the back of each card

Cover design by Richard Aquan

ISBN: 0-449-90579-9

Printed and bound in Singapore by Imago Publishing Limited
First American Edition: March 1991

10 9 8 7 6 5 4 3 2 1

FOREWORD

*F*or centuries painters have attempted to capture feminine beauty on canvas. This varied collection, spanning five hundred years, ranges from the serenity of the religious painting of the Renaissance, via the splendor of eighteenth-century portraiture and the unworldliness of the Pre-Raphaelite dream of women, to the delicacy of Degas's dancer and the simple dignity of Gauguin's Tahitian girl; from the sophistication of Bloomsbury to the mischievous charm of Montmartre.

With all their variety of period, treatment and mood, and in spite of changing ideas about what constitutes beauty in women, these images have lost none of their appeal. It is all the more regrettable that, with the advent of the camera, serious painters have all but abdicated this once most satisfying role. The aristocracy and statesmen may still pose for posterity, but today the needy model and the society beauty are both less likely to be found amid the pungent ambiance of the artist's studio than in the high-tech environment of the photographer's. The extent of the loss may be gauged from this striking gallery of images.

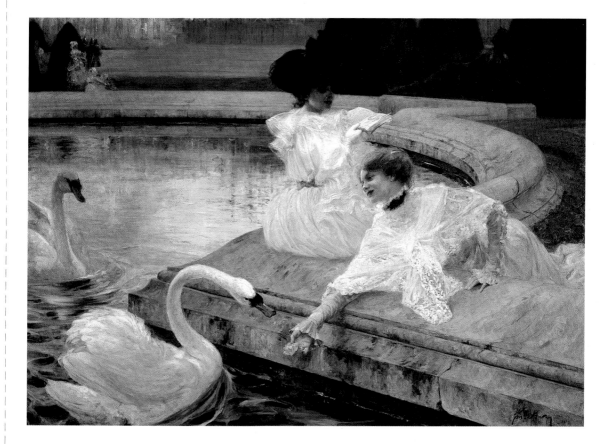

FAWCETT COLUMBINE NEW YORK

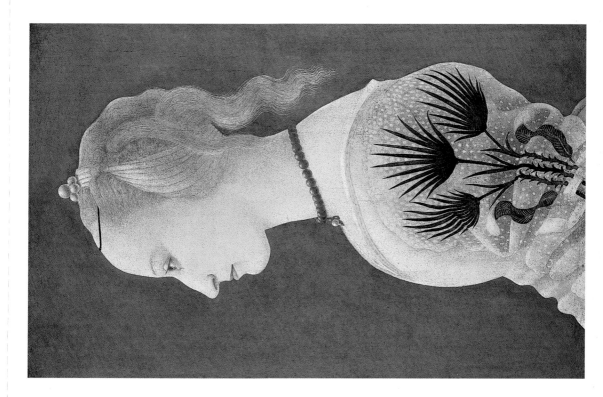

ALESSO BALDOVENETTI (c.1426-1499)
A Portrait of a Lady in Yellow

FAWCETT COLUMBINE NEW YORK

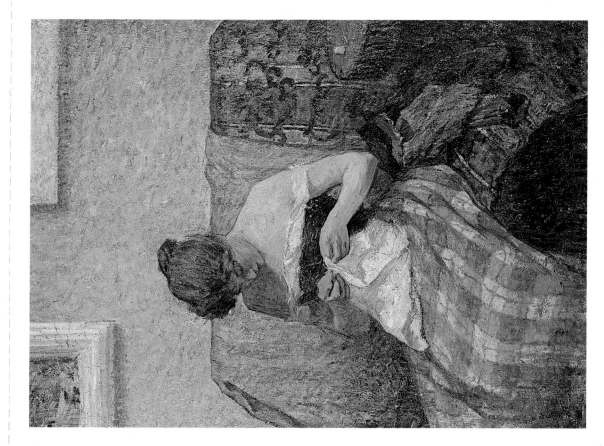

HENRI LABASQUE (1865-1937)
Femme Cousant
CHRISTIE'S, LONDON/THE BRIDGEMAN ART LIBRARY, LONDON

FAWCETT COLUMBINE NEW YORK

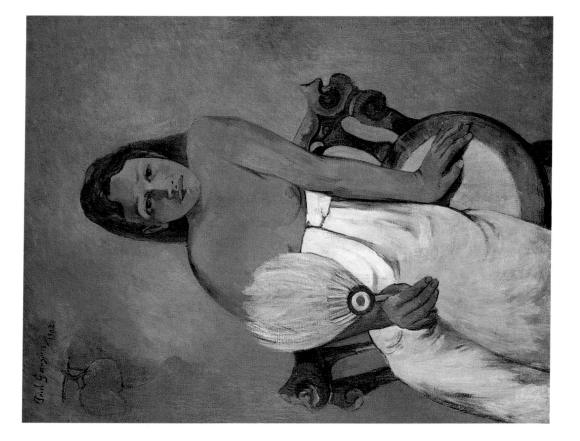

PAUL GAUGUIN (1848-1903)
Girl with Fan
MUSEUM FOLKWANG, ESSEN, GERMANY/THE BRIDGEMAN ART LIBRARY,
LONDON

FAWCETT COLUMBINE NEW YORK

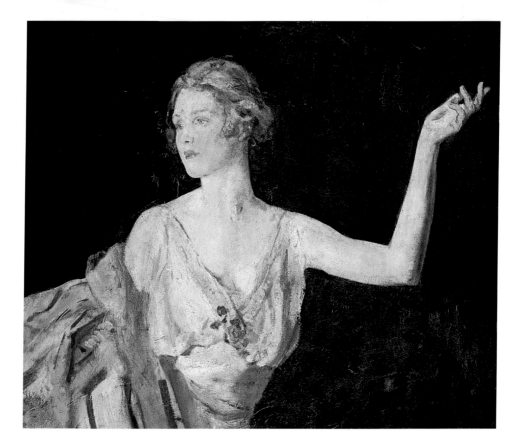

FAWCETT COLUMBINE NEW YORK

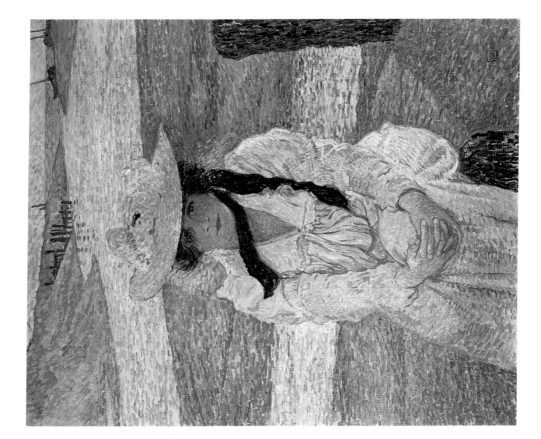

THEO VAN RYSSELBERGHE (1862-1926)
Young Woman at the banks of the Greve River
PRIVATE COLLECTION/THE BRIDGEMAN ART LIBRARY

FAWCETT COLUMBINE NEW YORK

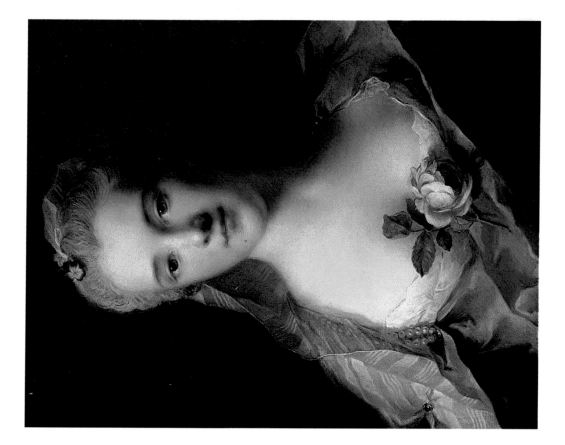

J. M. NATTIER (1685-1766)
Manon Balletti

FAWCETT COLUMBINE NEW YORK

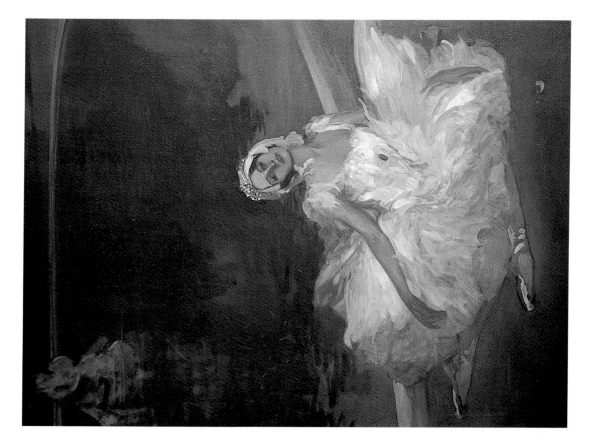

SIR JOHN LAVERY (1856-1941)
Anna Pavlova
THE TATE GALLERY, LONDON/E.T. ARCHIVE

FAWCETT COLUMBINE NEW YORK

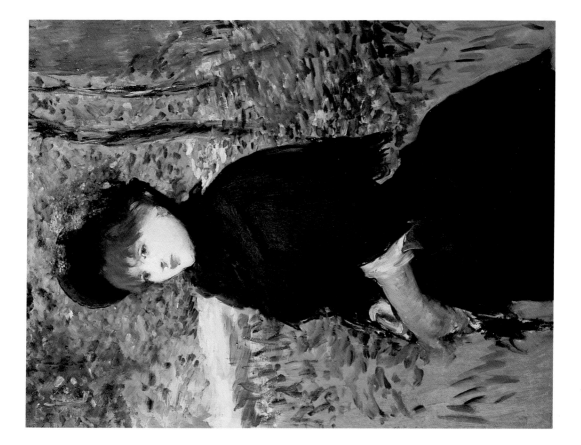

EDOUARD MANET (1832-83)
Le Promenade
CHRISTIE'S, LONDON/THE BRIDGEMAN ART LIBRARY, LONDON

FAWCETT COLUMBINE NEW YORK

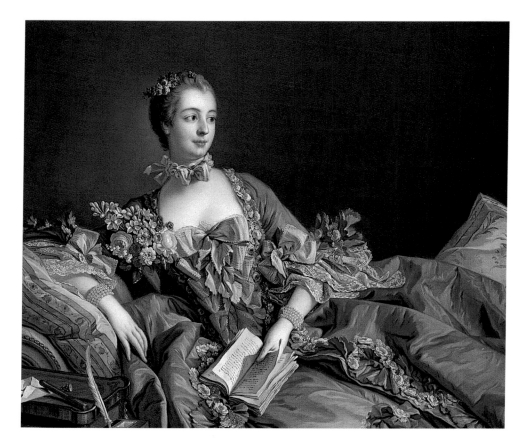

FRANCOIS BOUCHER (1703-1770)
Madame de Pompadour
THE NATIONAL GALLERY OF SCOTLAND/E.T. ARCHIVE

FAWCETT COLUMBINE NEW YORK

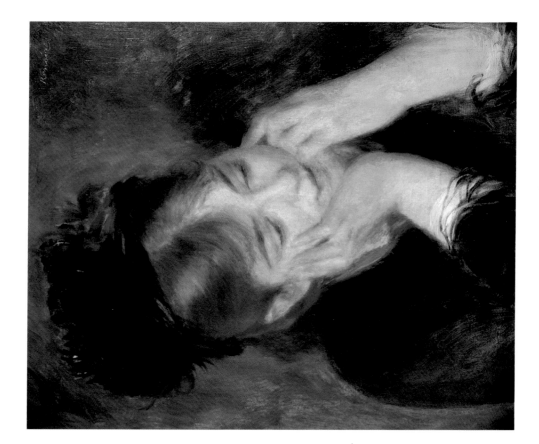

PIERRE AUGUSTE RENOIR (1841-1919)
Reflection
CHRISTIE'S, LONDON/THE BRIDGEMAN ART LIBRARY, LONDON

FAWCETT COLUMBINE NEW YORK

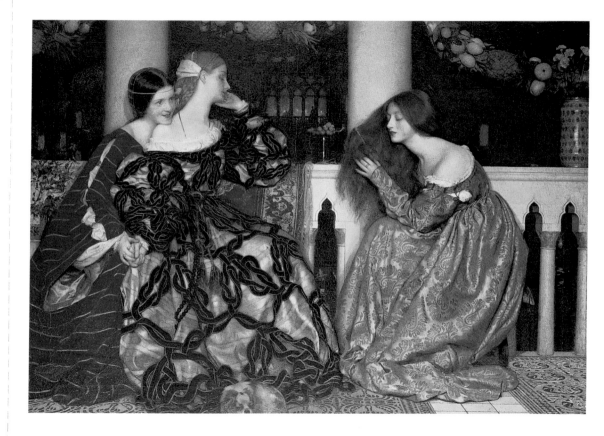

FRANK CADOGAN COWPER (1877-1958)
Venetian Ladies Listening to the Serenade
FINE ART PHOTOGRAPHIC LIBRARY, LONDON

FAWCETT COLUMBINE NEW YORK

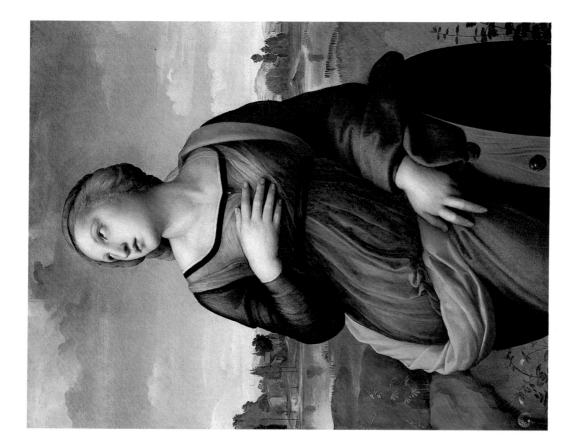

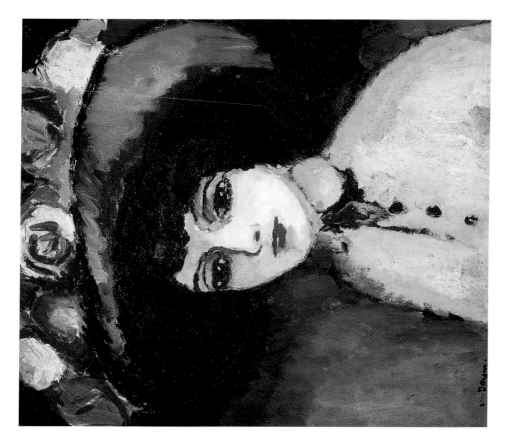

FAWCETT COLUMBINE NEW YORK

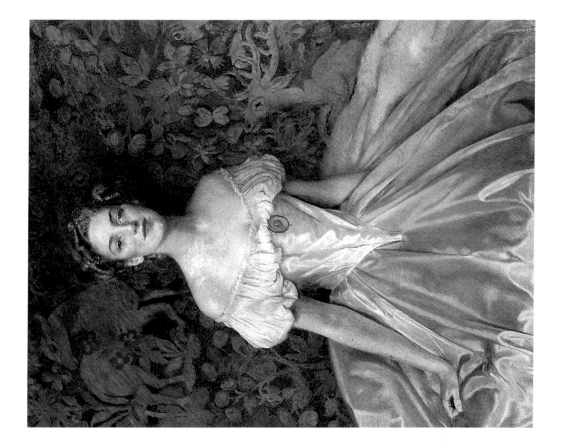

FRANK CADOGAN COWPER (1877-1958)
Elizabeth, Daughter of Major General F. V. B. Willis
FINE ART PHOTOGRAPHIC LIBRARY, LONDON

FAWCETT COLUMBINE NEW YORK

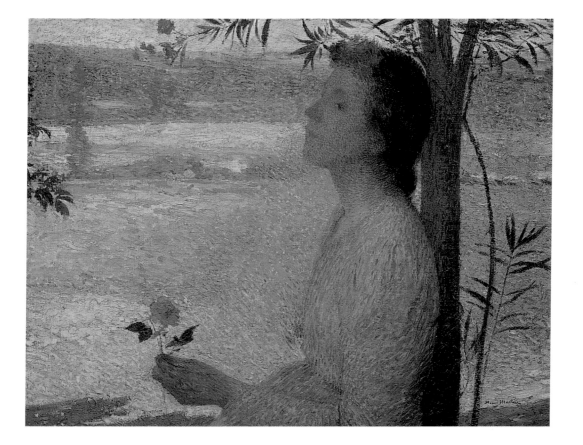

FAWCETT COLUMBINE NEW YORK

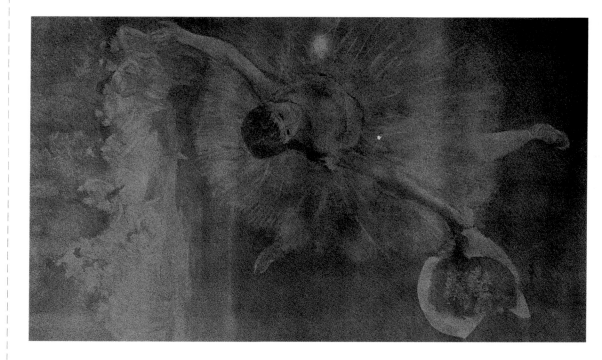

EDGAR DEGAS (1834-1917)
Fin d'Arabesque
THE LOUVRE, PARIS/THE BRIDGEMAN ART LIBRARY, LONDON

FAWCETT COLUMBINE NEW YORK

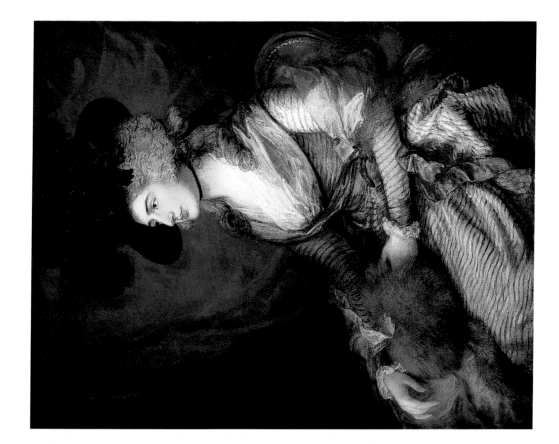

THOMAS GAINSBOROUGH (1727-1788)
Mrs Siddons
REPRODUCED BY COURTESY OF THE TRUSTEES,
THE NATIONAL GALLERY, LONDON

FAWCETT COLUMBINE NEW YORK

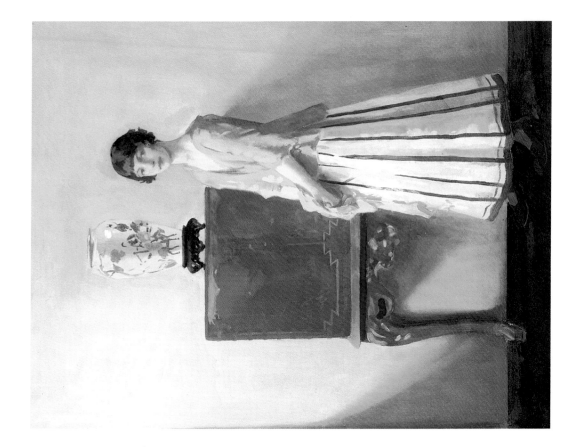

ARCHIBALD BARNES (b.1887)
The Red Lacquer Cabinet
OLDHAM ART GALLERY, LANCS/THE BRIDGEMAN ART LIBRARY,
LONDON

FAWCETT COLUMBINE NEW YORK

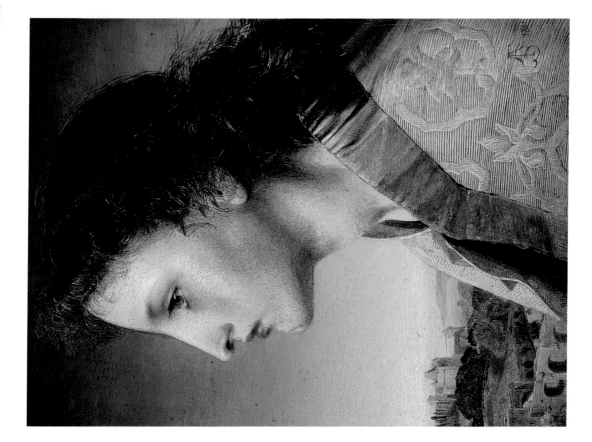

ANTONY FREDERICK AUGUSTUS SANDYS (1829-1904)
Oriana
FINE ART PHOTOGRAPHIC LIBRARY, LONDON

FAWCETT COLUMBINE NEW YORK

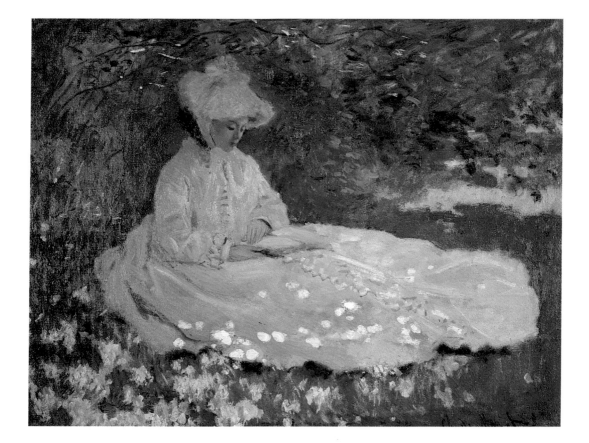

CLAUDE MONET (1840-1926)
A Woman Reading
WALTERS ART GALLERY, BALTIMORE/THE BRIDGEMAN ART LIBRARY,
LONDON

FAWCETT COLUMBINE NEW YORK

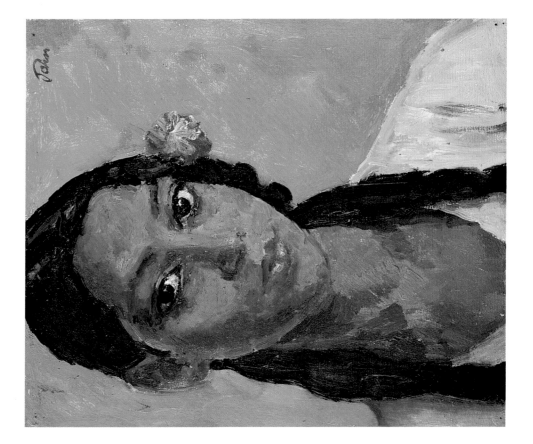

AUGUSTUS JOHN (1878-1961)
Head of a Jamaican Girl
PRIVATE COLLECTION/THE BRIDGEMAN ART LIBRARY, LONDON

FAWCETT COLUMBINE NEW YORK

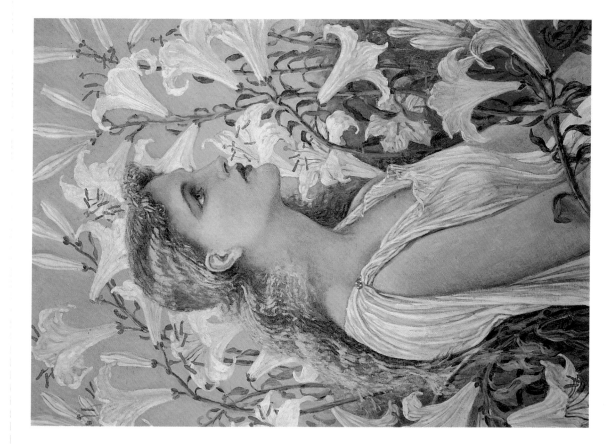

WALTER CRANE (1845-1915)
Lilies
FINE ART PHOTOGRAPHIC LIBRARY, LONDON

FAWCETT COLUMBINE NEW YORK

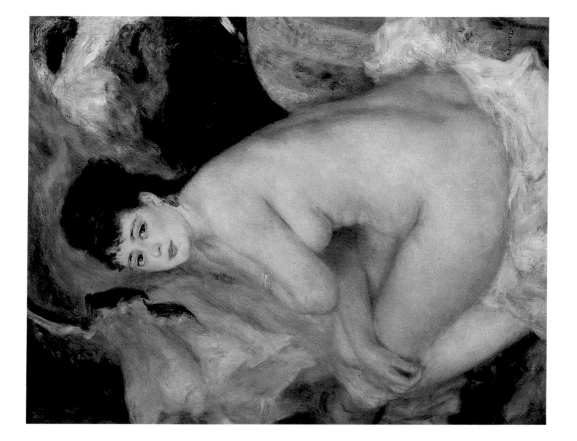

Pierre Auguste Renoir (1841-1919)
Nude, 1876
PUSHKIN MUSEUM, MOSCOW/THE BRIDGEMAN ART LIBRARY, LONDON

FAWCETT COLUMBINE NEW YORK

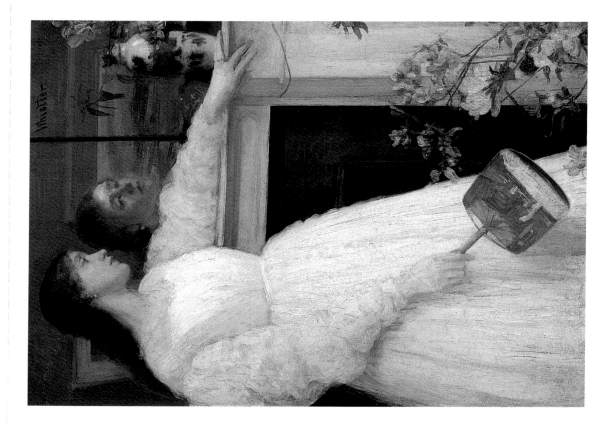

JAMES MCNEILL WHISTLER (1834-1903)
The Little White Girl: Symphony in White No II
THE TATE GALLERY, LONDON

FAWCETT COLUMBINE NEW YORK

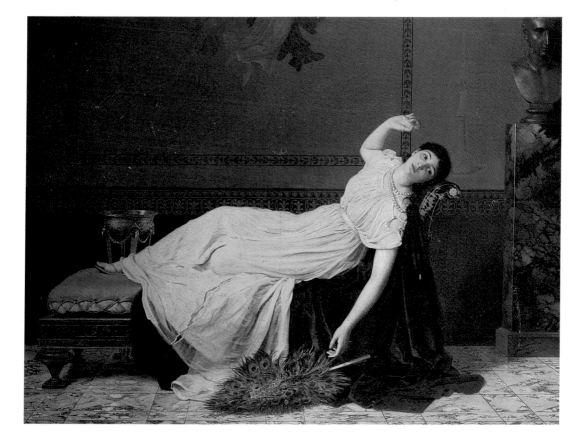

SOPHIE ANDERSON (1823-1898)
The Studio
FINE ART PHOTOGRAPHIC LIBRARY, LONDON

FAWCETT COLUMBINE NEW YORK

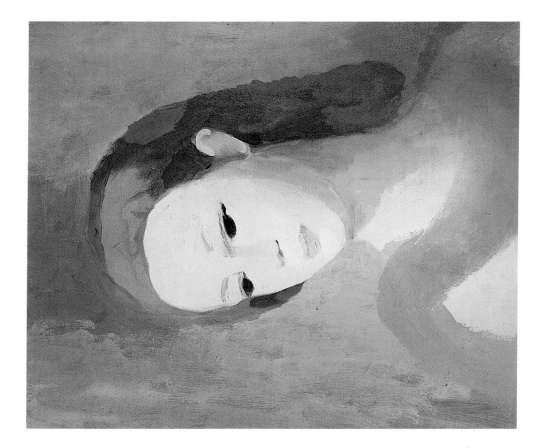

MARIE LAURENCIN (1883-1956)
Portrait of a Woman in a Blue Dress
CHRISTIE'S, LONDON/THE BRIDGEMAN ART LIBRARY,
LONDON/© ADAGP, PARIS AND DACS, LONDON 1991

FAWCETT COLUMBINE NEW YORK

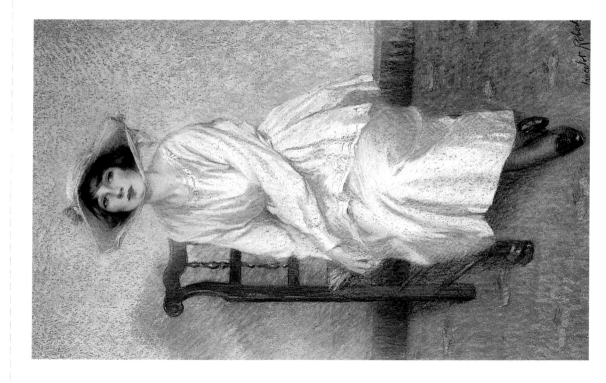

LANCELOT ROBERTS (1912-29)
Cynthie
OLDHAM ART GALLERY, LANCS/THE BRIDGEMAN ART LIBRARY,
LONDON

FAWCETT COLUMBINE NEW YORK

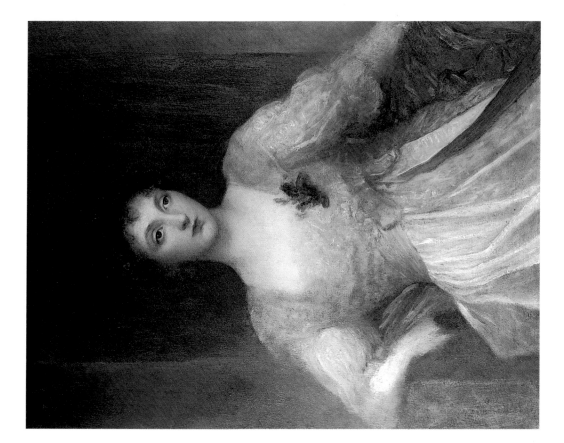

GEORGE FREDERICK WATTS (1817-1904)
Portrait of Miss Norah Bourke
FINE ART PHOTOGRAPHIC LIBRARY, LONDON

FAWCETT COLUMBINE NEW YORK

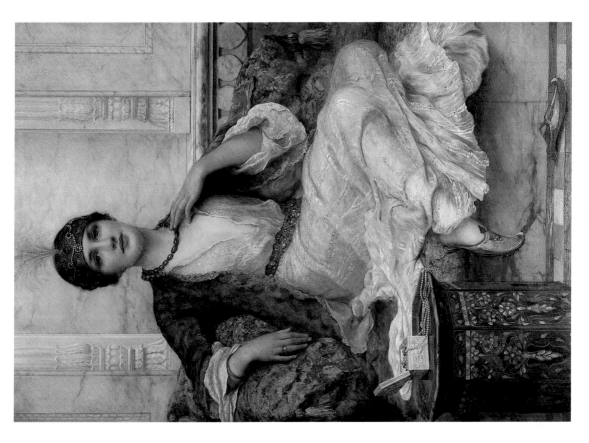

WILLIAM CLARK WONTNER (exh. 1879-1912)
The Jade Necklace
TOWNELEY HALL ART GALLERY AND MUSEUM, BURNLEY/THE
BRIDGEMAN ART LIBRARY, LONDON

FAWCETT COLUMBINE NEW YORK